Art Tiles

L A R K

S T U D I O S E R I E S

LARK CRAFTS
A Division of
Sterling Publishing Co., Inc.
New York / London

Library of Congress Cataloging-in-Publication Data

Lark studio series: art tiles / [senior editor, Ray Hemachandra]. – 1st ed.
 p. cm. – (Lark studio series)
 Includes index.
 ISBN 978-1-60059-681-0 (pbk. : alk. paper)
 1. Tile craft. 2. Tiles. 3. Art pottery. I. Hemachandra, Ray. II. Lark Books.
 TT927.A78 2010
 738.6–dc22

 2010004952

SENIOR EDITOR
Ray Hemachandra

EDITORS
Julie Hale
Larry Shea

ART DIRECTOR
Chris Bryant

LAYOUT
Skip Wade

COVER DESIGNER
Chris Bryant

10 9 8 7 6 5 4 3 2 1

First Edition

Published by Lark Books, A Division of
Sterling Publishing Co., Inc.
387 Park Avenue South, New York, NY 10016

Text © 2010, Lark Books, A Division of Sterling Publishing Co., Inc.
The tiles in this book appeared in 500 Tiles, juried by Angelica Pozo.

Photography © 2010, Artist/Photographer

Distributed in Canada by Sterling Publishing,
c/o Canadian Manda Group, 165 Dufferin Street
Toronto, Ontario, Canada M6K 3H6

Distributed in the United Kingdom by GMC Distribution Services,
Castle Place, 166 High Street, Lewes, East Sussex, England BN7 1XU

Distributed in Australia by Capricorn Link (Australia) Pty Ltd.,
P.O. Box 704, Windsor, NSW 2756 Australia

FRONT COVER
Hennie Meyer
FRAGMENTS
PHOTO BY ARTIST

BACK COVER
Laurie Eisenhardt
*THE QUEEN
AND KING*
PHOTO BY RICHARD DOYLE

If you have questions or comments about this book, please contact:
LARK CRAFTS | 67 Broadway | Asheville, NC 28801 | 828-253-0467

Manufactured in China

ISBN 13: 978-1-60059-681-0

For information about special sales, contact the Sterling Special Sales Department at
800-805-5489 or specialsales@sterlingpub.com.

CONTENTS

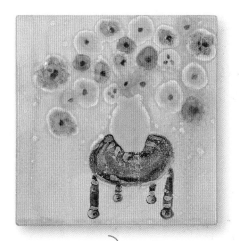

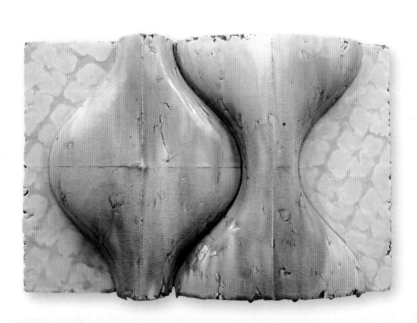

INTRODUCTION

The Lark Studio Series is designed to give you an insider's look at some of the most exciting work being made by artists today. The art tiles we've selected range from whimsical to sobering to just plain gorgeous. They showcase leading ceramists' abstract invention or jolting realism and come together to create a pocket book of near endless visual delight for art lovers.

Lauren Lewis Butcher

PATH

22 x 24 x 1 1/2 inches (55.9 x 61 x 3.8 cm)

Slab- and hand-built earthenware; electric
fired, cone 04; oxide wash, cone 04

PHOTO BY STEVE MANN

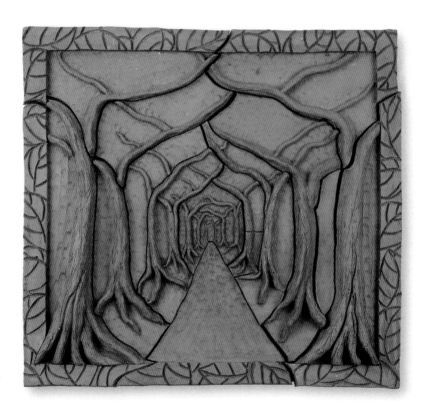

Simon Levin

STICK TRIVET

8 x 8 x 1 inches (20.3 x 20.3 x 2.5 cm)

Hand-built stoneware with inlaid slips;
wood fired in anagama kiln, cone 10

PHOTO BY ARTIST

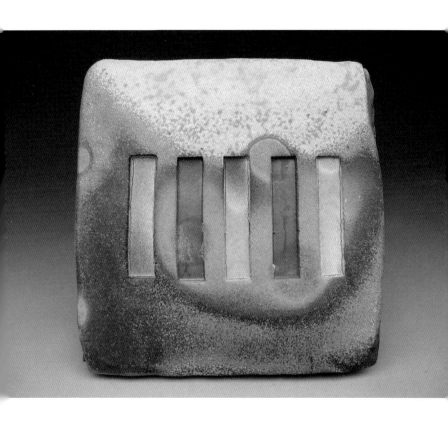

Valerie Nicklow
Jonathan Nicklow

THE CHRONOLOGER

16 x 12 x $\frac{1}{2}$ inches (40.6 x 30.5 x 1.3 cm)

Low-fire white clay; electric fired, cone 04; slab-rolled, relief
sculpture, stamped elements with oil paints and varnish

PHOTO BY ARTIST

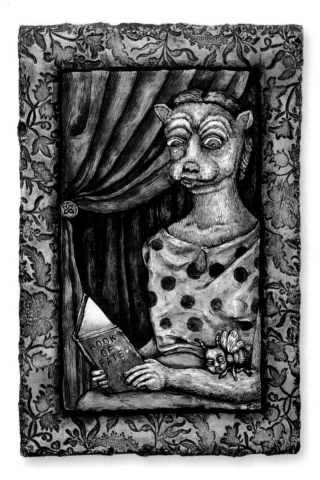

Hwang Jeng-daw

MECHANICAL TIME
79 x 118 x 4 inches (200 x 300 x 10 cm)

Slab-built stoneware; gas fired, glazed, cone 9;
gold and platinum luster, cone 012

PHOTO BY ARTIST

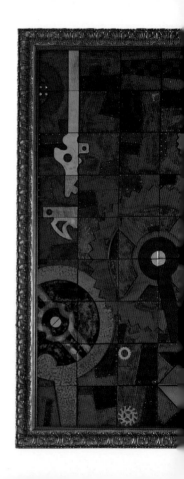

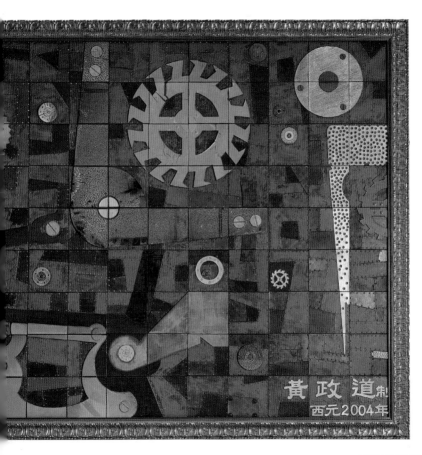

黃 政 道 制
西元2004年

Tiffany Schmierer

THE SWAN
16 x 19 x 5 inches (40.6 x 48.3 x 12.7 cm)

Hand-built earthenware; electric fired, cone 04; underglaze
and glaze firing, cone 06 and 07; luster firing, cone 019

PHOTO BY JAY JONES

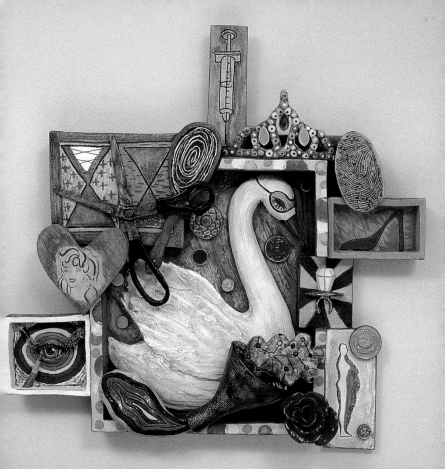

Brooks Bouwkamp

BLUE CRYSTALLINE TILE
3 3/4 x 3 3/4 x 1/2 inches (9.5 x 9.5 x 1.3 cm)

Hand-built white stoneware; electric fired, cone 10

PHOTO BY DAVE SHERWIN

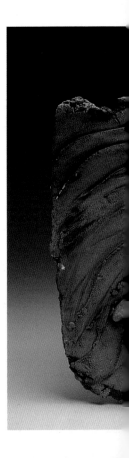

Novie Trump

SEA TURTLES
8 x 14 x 1 inches (20.3 x 35.6 x 2.5 cm)

Mid-range, outdoor sculpture body clay; electric fired, cone 06;
glazed with Mason stains, oxides, and slips, cone 6

PHOTO BY GREG STALEY

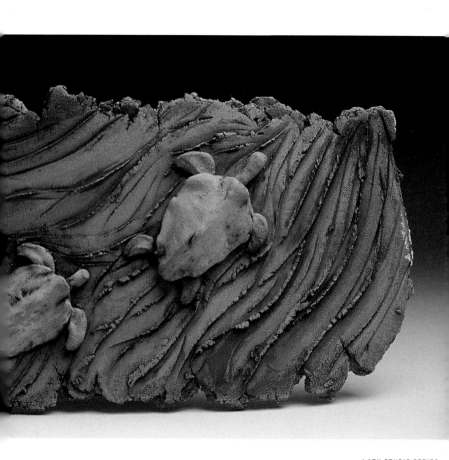

Keri Huber

BLUEBIRD

4 x 5¼ x ½ inches (10.2 x 13.3 x 1.3 cm)

Hand-built earthenware; bisque fired,
cone 04; terra sigillata, pit fired

PHOTO BY JERRY MATHIASON

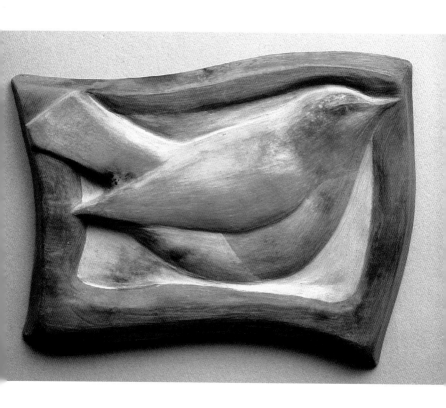

Irina Clopatofsky Velasco

PRAIRIE BISON

6½ x 6½ x ¼ inches (15.9 x 15.9 x 0.6 cm)

Pressed stoneware; glass, oxides;
electric fired, cone 6

PHOTO BY ERIC KANE

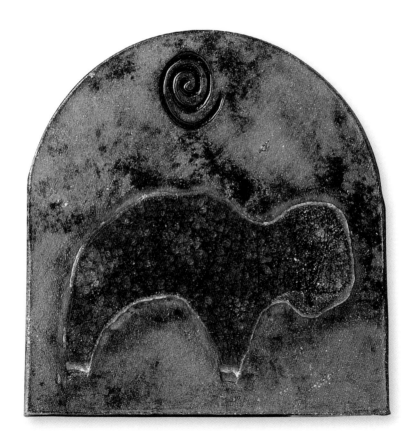

Cathryn R. Hudin
Lee Hudin

BRAIDED HAIR

24 x 24 x 1 inches (61 x 61 x 2.5 cm)

Raku clay; raku fired, cone 05;
hand drawn; artists' glazes

PHOTO BY ARTISTS

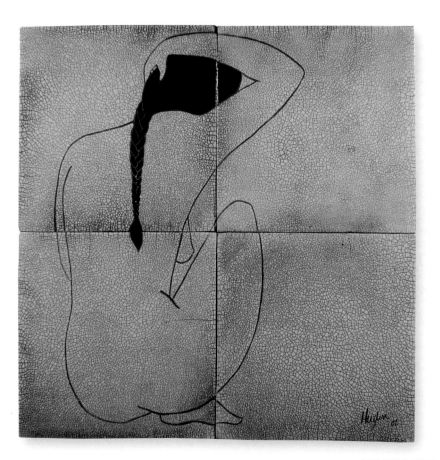

Sandy Culp

PEAR PAIR
8 x 12 x 1½ inches (20.3 x 30.5 x 3.8 cm)

Hand-built Lizella clay; bas relief, iron oxide;
electric fired in oxidation, cone 6

PHOTO BY ARTIST

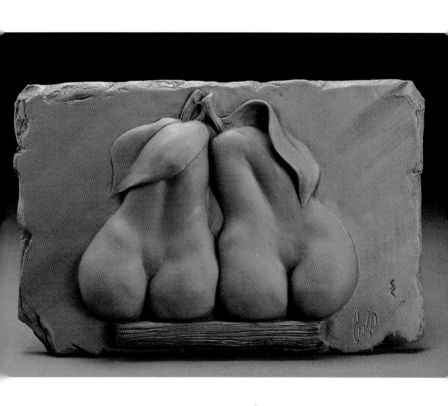

Wynne Wilbur

UNTITLED
4 x 4 inches (10.2 x 10.2 cm)

Maiolica on white earthenware; electric fired, cone 03

PHOTO BY ARTIST

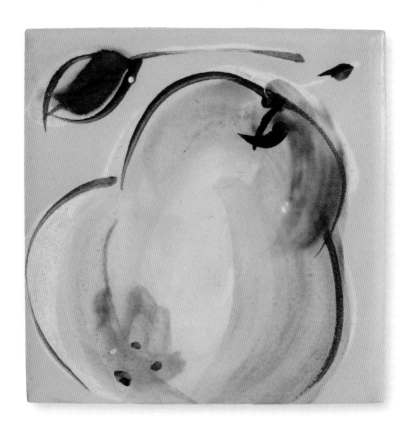

Doug Spalding

OBEY
4¾ x 7 inches (12 x 17.8 cm)

Raku stoneware fired to 1900°F (1038°C),
decorated with cuerda seca method

PHOTO BY JIM MCCLEAR

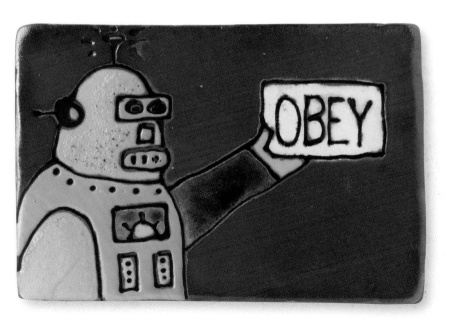

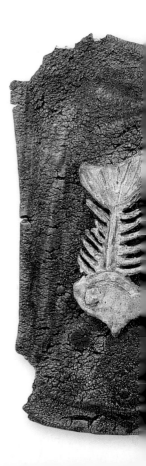

Rena Fafalios

AEGEAN FRIEZE
8¾ x 12¼ x ¾ inches (22.2 x 31.1 x 1.9 cm)

Stoneware, slips; electric fired, cone 6; acrylics

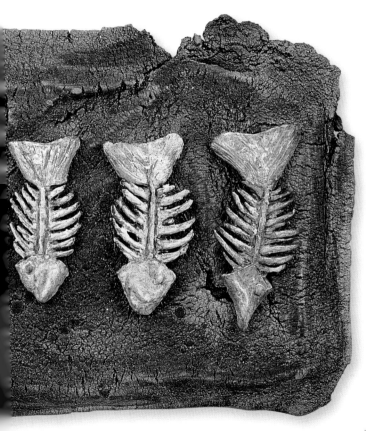

Laura Litvinoff

PINE TILE

8 x 8 x $\frac{1}{8}$ inches (20.3 x 20.3 x 0.3 cm)

Hand-cut white stoneware slab; pine branch
impression; clear glaze; reduction fired, cone 10

PHOTO BY JACK REZNICKI

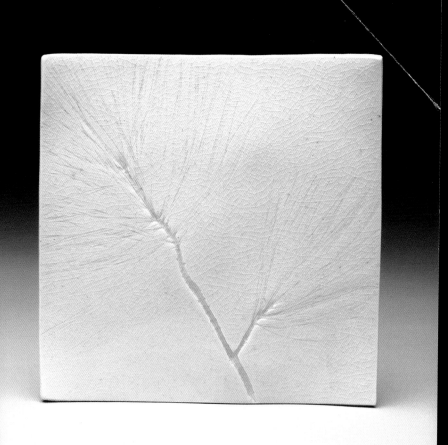

Kristin Antonsen

SALAMANDER

$6\frac{1}{4}$ x $4\frac{1}{2}$ x $\frac{3}{8}$ inches (15.9 x 11.5 x 1 cm)

Slab-built and textured white stoneware;
electric fired, cone 06; oxides, cone 6

PHOTO BY JOHN ERIK KRISTENSEN

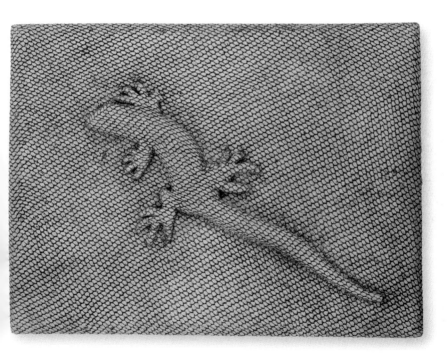

Sharon Bartmann

MOTHER NATURE
24 x 12 x 1¼ inches (61 x 30.5 x 3.2 cm)

Press-molded and sculpted mosaic; raku fired, cone 06

PHOTO BY PEG PETERSON

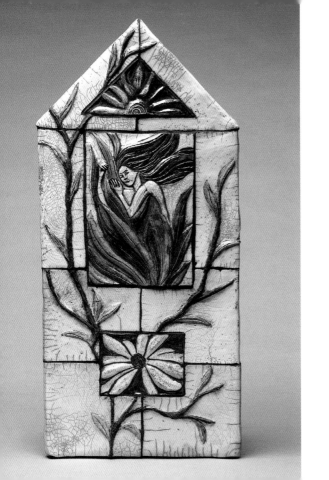

Linda Kliewer

SPREKELIA FLOWER
10 x 10 inches (25.4 x 25.4 cm)

Stoneware; electric fired, cone 5

PHOTO BY COURTNEY FRISSE

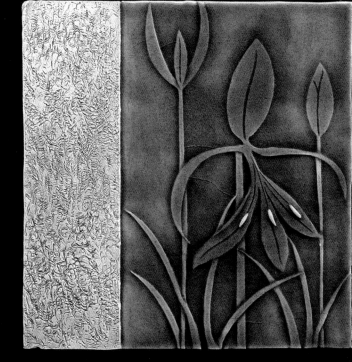

Gary Warkentin

BALD CYPRESS WITH MOON

10 x 5 x $\frac{1}{2}$ inches (25.4 x 12.7 x 1.3 cm)

Press-molded earthenware; electric fired,
cone 04; glazed, cone 06

PHOTO BY COURTNEY FRISSE

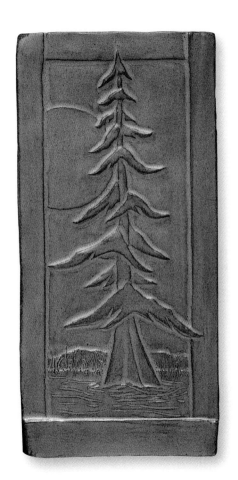

Ji Youl Choi

SPRING
Each: 5⁷⁄₈ x 5⁷⁄₈ x ³⁄₁₆ inches (15 x 15 x 0.5 cm)

Porcelain; electric fired, cone 10

PHOTO BY ARTIST

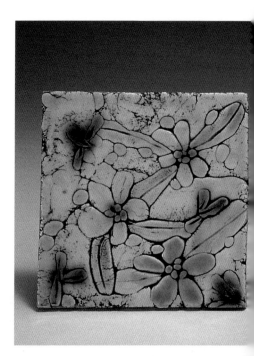

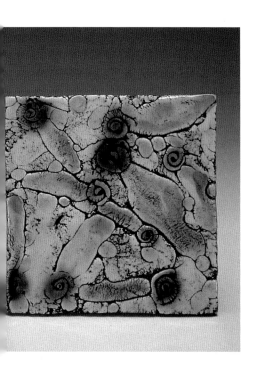

Laura McCaul

TWO BLACKBIRDS IN REEDS

6 x 8½ x ⅜ inches (15.2 x 21.6 x 1 cm)

Hand-pressed red earthenware; terra sigillata;
electric fired, cone 06; wood fired in barrel kiln

PHOTO BY ARTIST

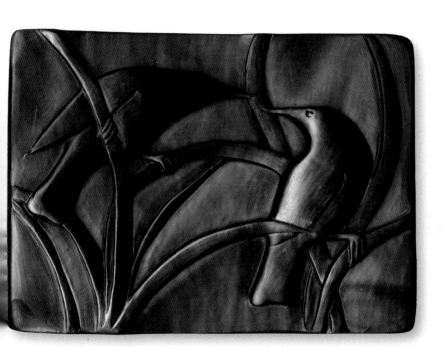

Jenny Mendes

THE MIDNIGHT GARDENER
11 x 8½ x ¼ inches (27.9 x 21.6 x 0.6 cm)

Hand-rolled earthenware slab; terra sigillata
with sgraffito; electric fired, cone 03

PHOTO BY TOM MILLS

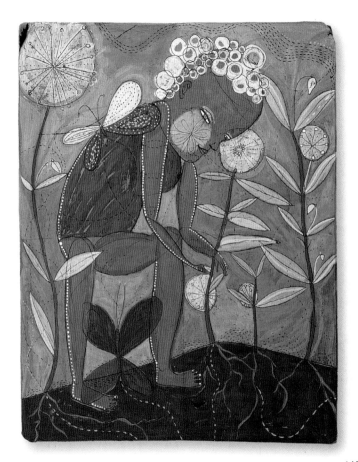

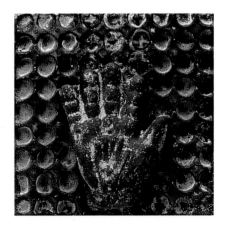

Lana Wilson

ALMOST A DOZEN HANDS

12 x 9 x 1 1/2 inches (30.5 x 22.9 x 3.8 cm)

Stamped white stoneware; electric fired,
glaze firings cones 6 and 04

PHOTOS BY ARTIST

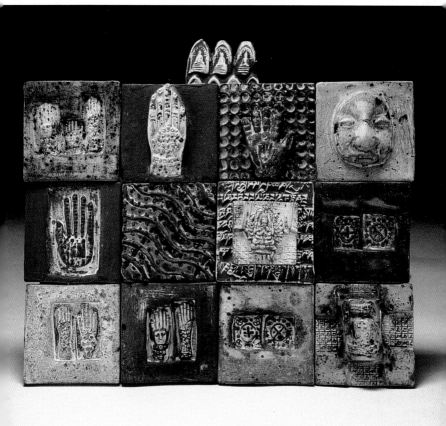

Paul Andrew Wandless

FLYER

14 x 14 x ½ inches (35.6 x 35.6 x 1.3 cm)

Monotype, linocut embossed on white stoneware;
electric fired, cone 04; slips, glaze, cone 04

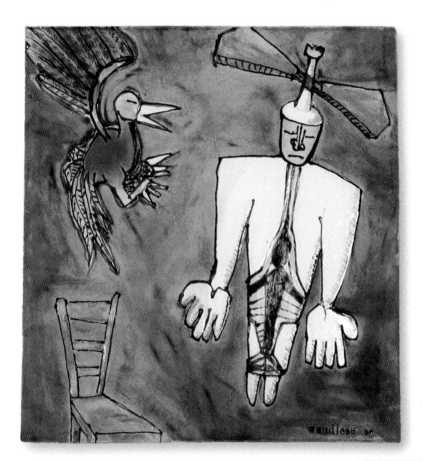

wandless

Dalia Laučkaitė-Jakimavičiené

A WINDOW

23⁹/₁₆ x 55 x ³/₈ inches (60 x 140 x 1 cm)

Manufactured tiles, glazes, laser print decals; cone 07,
onglaze decals, china paints, gold, and lusters; cone 016

PHOTO BY VIDMANTAS ILLČIUKAS

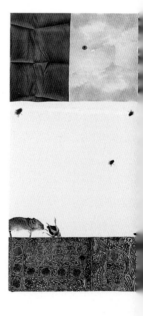

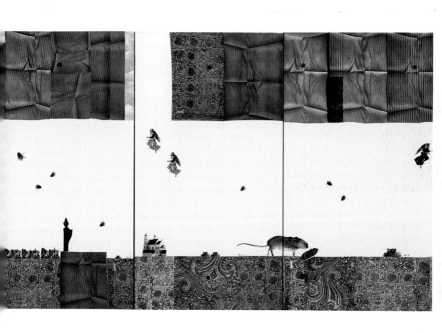

Laurie Eisenhardt

THE QUEEN AND KING
Each: 6 x 6 inches (15.2 x 15.2 cm)

Press-molded, low-fire clay body;
underglazes and glazes

PHOTOS BY RICHARD DOYLE

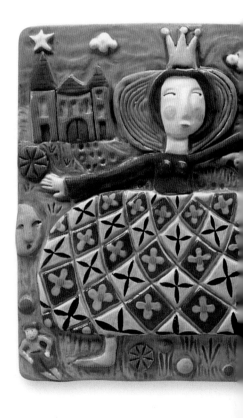

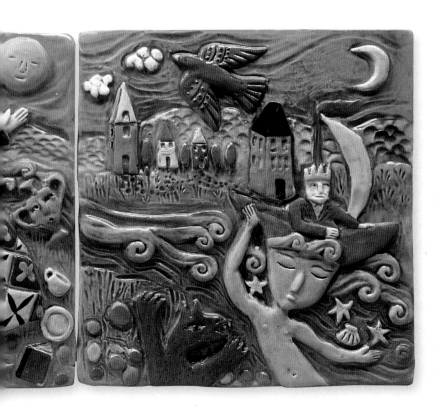

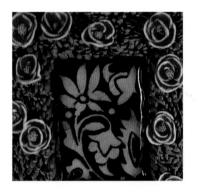

Amanda Jaffe

GENTLE WAVES II

8 x 7 x 1½ inches (20.3 x 17.8 x 3.8 cm)

Carved porcelain; flowers glazed to surface; underglaze
and glaze; single-fired in electric kiln, cone 5

PHOTOS BY ARTIST

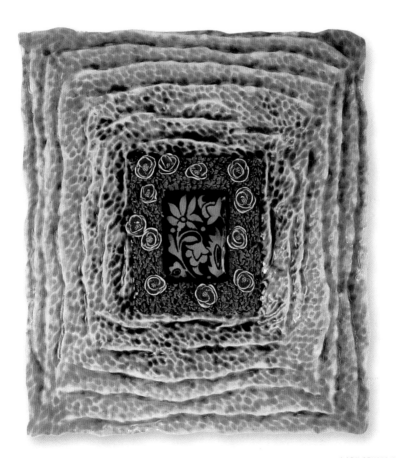

Dot Kolentsis

MUSICIAN
11³⁄₄ x 11³⁄₄ inches (30 x 30 cm)

White earthenware; electric fired,
2102°F (1100°C), hand-painted maiolica

PHOTO BY JENNI CARTER

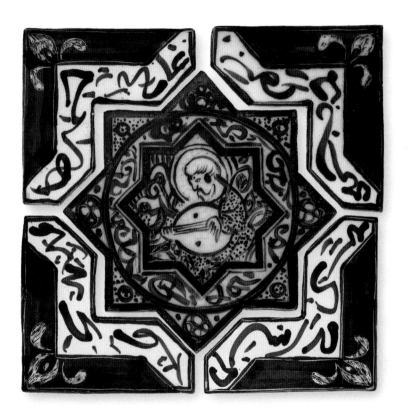

Laura A. Reutter

REVERIE
17 x 12 x ½ inch (43.2 x 30.5 x 1.3 cm)

Press-molded stoneware, grout; electric fired,
bisqued, cone 05; glazed, cone 5

PHOTO BY FRANK ROSS

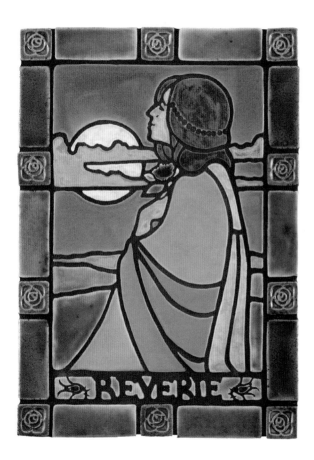

Joan Rothchild Hardin

FLOWERS IN BLUE VASE

6 x 6 x ¼ inches (15.2 x 15.2 x 0.6 cm)

Hand-painted commercial bisque tile;
Amaco glazes; electric fired, cone 05

PHOTO BY D. JAMES DEE

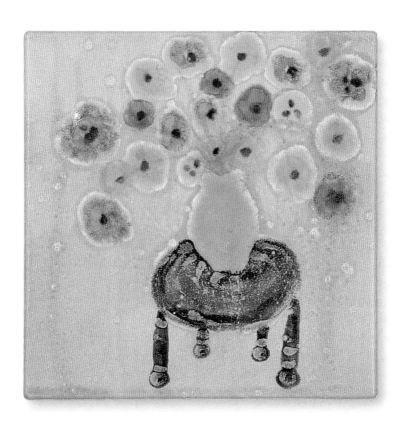

Debra Felix

DRAGONFLY TILE

8 x 6 x ½ inches (20.3 x 15.2 x 1.3 cm)

White earthenware; texture stamping; electric fired,
cone 05; painted with crackle glazes

PHOTO BY ARTIST

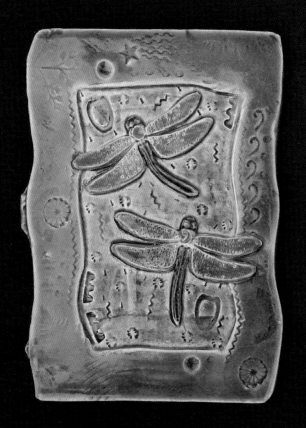

Jason H. Green

COUPLING
13 x 21 x 4 inches (33 x 53.3 x 10.2 cm)

Press-molded terra cotta, slip; glaze, cone 04

PHOTO BY ARTIST

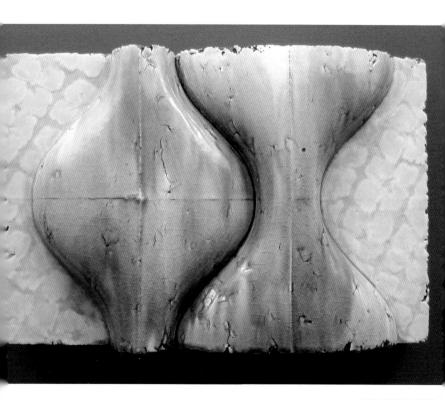

Rebeca D. Gilling

ROSEMARY

11 x 13 x ½ inches (27.9 x 33 x 1.3 cm)

Hand-built; electric fired; glazed

PHOTO BY J. KING

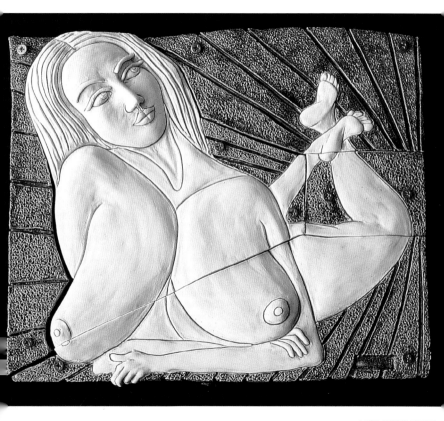

Lorraine Sutter

WHITE T
4^{11}/$_{16}$ x 7^{7}/$_{8}$ x 2^{9}/$_{16}$ inches (12 x 20 x 6.5 cm)

Slab- and coil-built low-fire paper clay;
carved and impressed

PHOTO BY AK PHOTOS

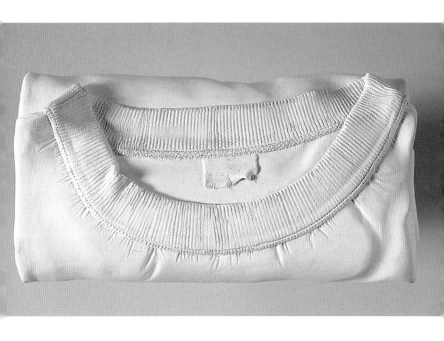

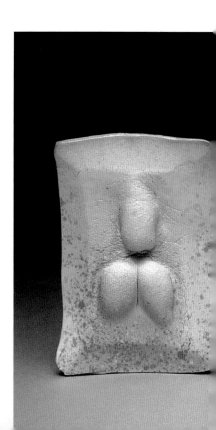

Marta Matray

THREE SILLY TILES
Tallest: 4 x 3 x ½ inches (10.2 x 7.6 x 1.3 cm)

Hand-built porcelain; soda glaze, cone 10

PHOTO BY PETER LEE

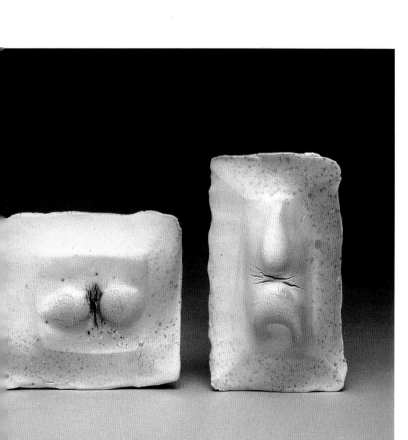

Lisa Wolters

SHELL HOUSE
8 x 10 inches (20.3 x 25.4 cm)

Stoneware; electric fired, glazes,
cone 6; shells, glass, tessera

PHOTO BY BOB WINNER

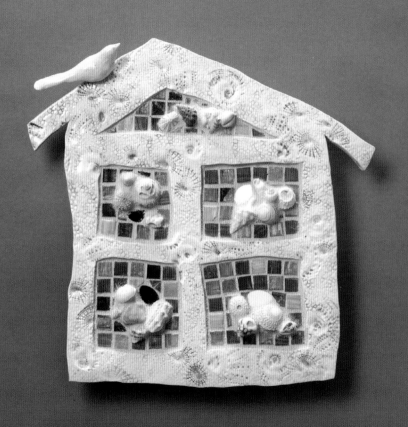

Janey Skeer

BLUE WINDOW

19 x 9 x 1½ inches (48.3 x 22.9 x 3.8 cm)

Hand-built; terra sigillata and stain surface work, stamped
impressions; cone 04, bisque; electric fired, cone 3

PHOTO BY CHARLIE ROY

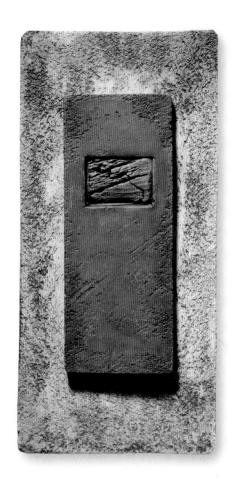

Ruchika Madan

TOOL TILE TRIO

Each: 4 x 4 x 3/8 inches (10.2 x 10.2 x 1 cm)

Press-molded white stoneware;
sgraffito; glazed, cone 6

PHOTO BY ARTIST

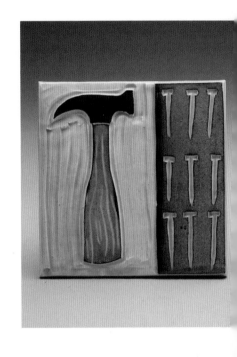

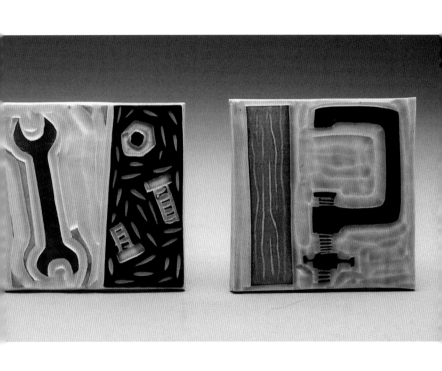

John Heaney

TILE
10$\frac{1}{4}$ x 13$\frac{3}{8}$ x 1$\frac{3}{16}$ inches (26 x 34 x 3 cm)

Slab-built Rye's Soda Feldspar
stoneware; wood fired, unglazed

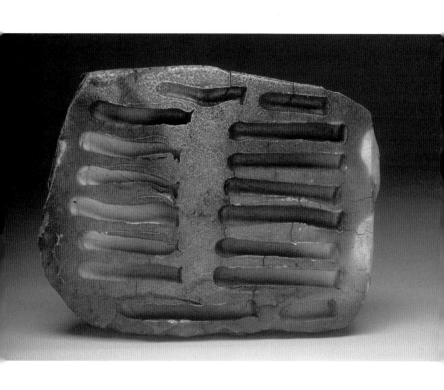

Hennie Meyer

FRAGMENTS

Each: 2 ¾ x 2 ¾ x 2 ¾ inches (7 x 7 x 7 cm)

Slab-built earthenware, painted slip;
glaze, oxides; electric fired, cone 2

PHOTO BY ARTIST

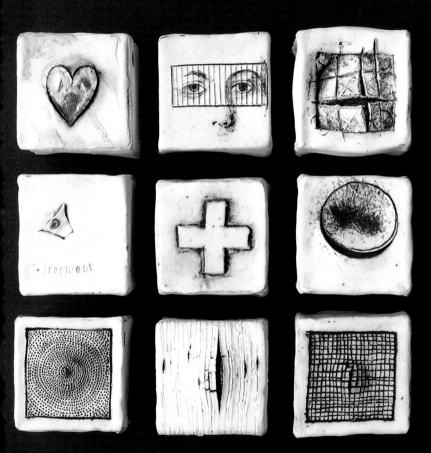

Ellen Huie

LIGHT DUSTING OF SNOW
Each: 6 x 6 inches (15.2 x 15.2 cm)

Red earthenware with tile 6 slip; soda fired, cone 04

PHOTO BY SEAN SCOTT

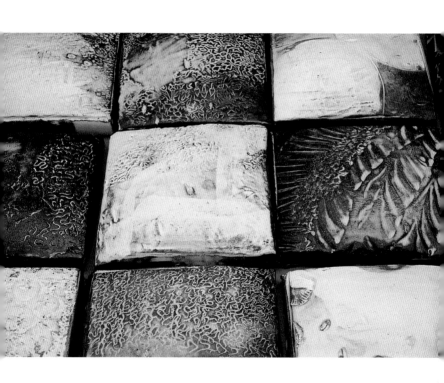

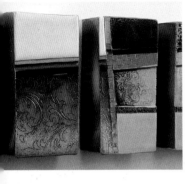

Miranda Howe

GEOMETRIC LANDSCAPE

5½ x 35 x 2 inches (14 x 88.9 x 5.1 cm)

Slab-constructed porcelain;
soda and salt fired, cone 10

PHOTOS BY RENNAN REIKE

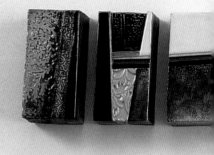

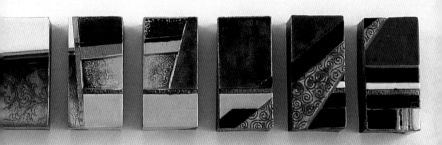

Betsy Cox

RED BALL NUMBER 2
12 x 12 x 3 inches (30.5 x 30.5 x 7.6 cm)

Press-molded stoneware; electric fired,
cone 6; matte glaze, cone 06

PHOTO BY ARTIST

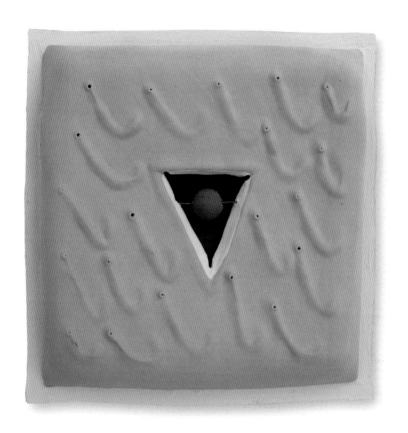

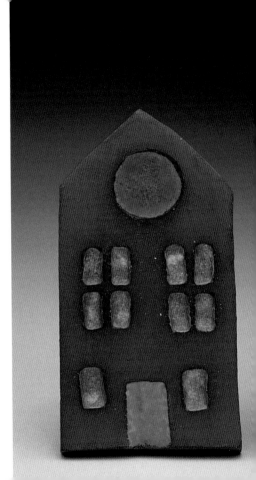

Chloë Marr-Fuller

TWO HOUSES

Each: 3 x 1¾ inches (7.6 x 4.4 cm)

Slab-rolled terra cotta; electric
fired, cone 04; carved, glazed

PHOTO BY MONICA RIPLEY

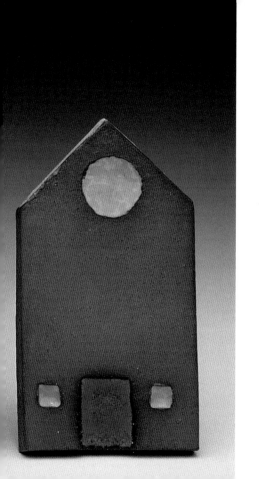

Darren L. Cockrell

SHOWER TILES

Each: 6 x 3 x ¾ inches (15.2 x 7.6 x 1.9 cm)

Slab-rolled and hand-cut stoneware;
wood-fired, natural ash glaze, cone 12

PHOTO BY DONALD J. FELTON

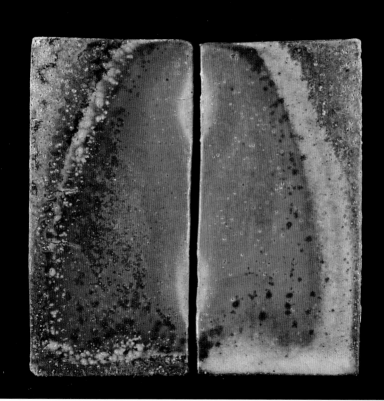

Priscilla Hollingsworth

TEAPOT RELIQUARY WOVEN WITH PURPLE
13 1/2 x 14 x 3 inches (34.3 x 35.6 x 7.6 cm)

Hand-built terra cotta; electric fired, glazed,
cone 04; acrylic paint; reduction fired, cone 10

PHOTO BY ARTIST

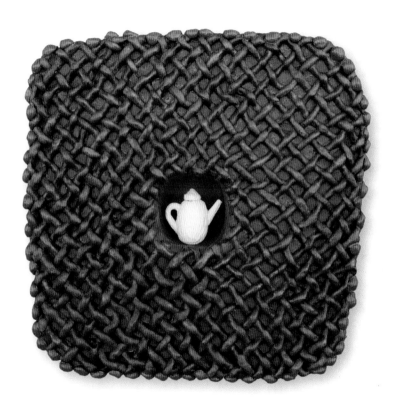

Michael Cohen

ASPARAGUS

6 x 6 x ¼ inches (15.2 x 15.2 x 0.6 cm)

Hand-stamped stoneware tile; gas fired,
cone 9; blue glaze overall, glass

PHOTOS BY ARTIST

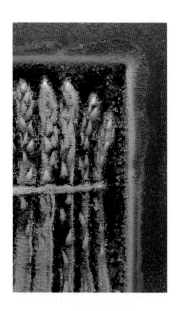

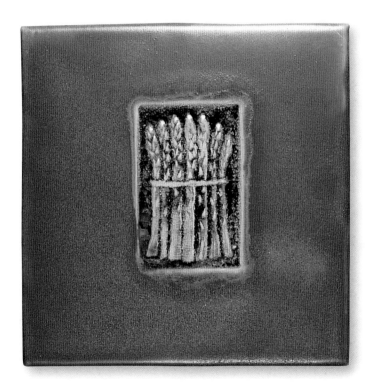

Shawn Newton

LADY WITH FLOWER
12 x 12 x ¼ inches (30.5 x 30.5 x 0.6 cm)

Porcelain tile mosaic; unglazed

PHOTO BY ARTIST

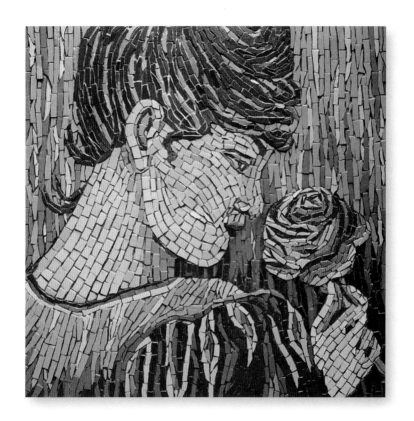

Bryan Hiveley

DR. LITTLE KITTY BATTLES THE SERPENT
11 x 11 x 1½ inches (27.9 x 27.9 x 3.8 cm)

Slab-built and carved stoneware;
 oil patina; oxidation fired, cone 04

PHOTO BY ARTIST

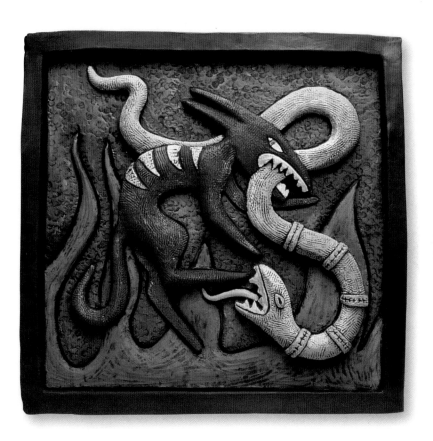

Garrett Angelich

SORROWFUL BOB

8 x 8 inches (20.3 x 20.3 cm)

Press-molded Navajo Wheel stoneware from original
sculpture; terra sigillata, underglaze, nickel oxide wash
and wood shavings; electric fired, cone 04

PHOTO BY ARTIST

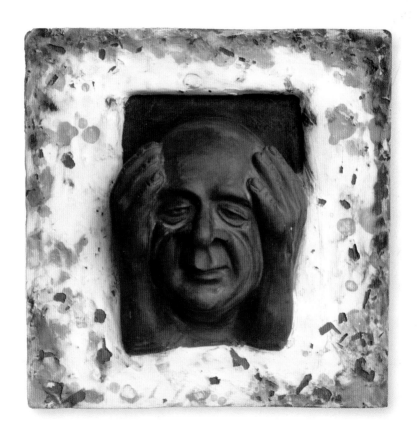

Laura Farrow

HOLDING 1: ANTELOPE
13 x 8 x ½ inches (33 x 20.3 x 1.3 cm)

Bas-relief earthenware; underglazes, glazes; raku fired

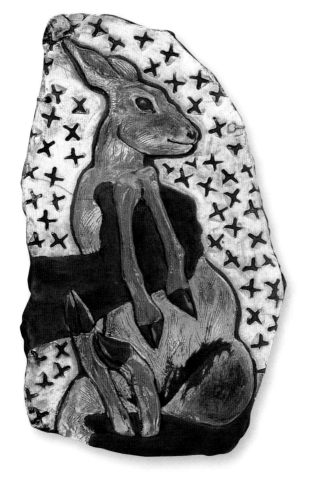

Jan Robb

BLEEDING HEARTS
8 x 4 x ½ inches (20.3 x 10.2 x 1.3 cm)

Press-molded porcelain; electric fired, cone 5

PHOTO BY MARK TRUPIANO

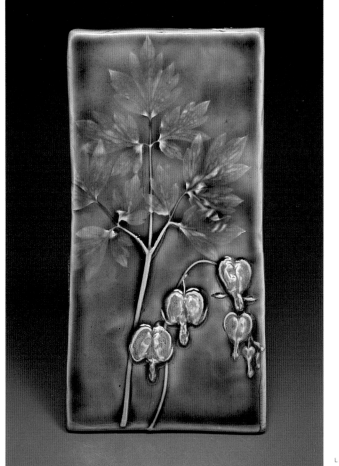

Frank Ozereko

HORSE
6 x 6 x 6 inches (15.2 x 15.2 x 15.2 cm)

Glaze painted; electric fired, cone 04

PHOTO BY ARTIST

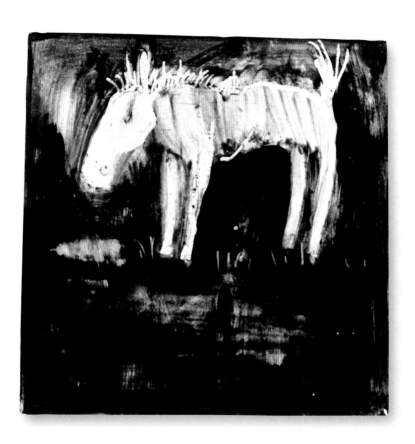

Shay Amber

DIGGING IN THE DIRT
9 x 9 x 2 inches (22.9 x 22.9 x 5.1 cm)

Stiff-slab construction; multi-fired, cone 016, decal

PHOTO BY STEVE MANN

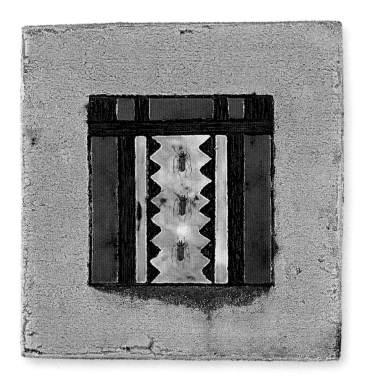

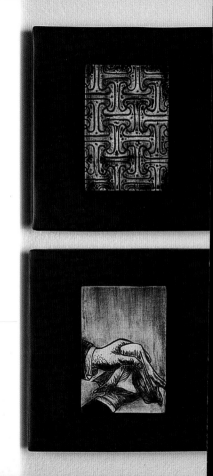

Susan Wink

CURIOS

Each: 6⅛ x 6⅛ x ¾ inches (15.5 x 15.5 x 1.9 cm)

White stoneware; glaze and underglaze;
electric fired, cone 6

PHOTO BY JOSE RIVERA

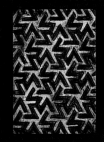
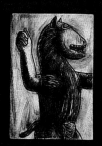

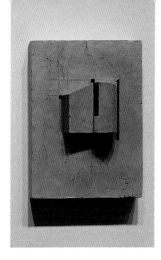

Nicholas Wood

TABLETS: EXTERIORS #8

16 x 86 x 4½ inches (40.6 x 218.4 x 11.4 cm)

Press-molded and carved terra cotta;
electric fired, cone 04; glazed, cone 04

PHOTOS BY ARTIST

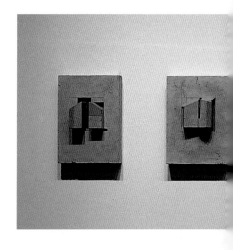

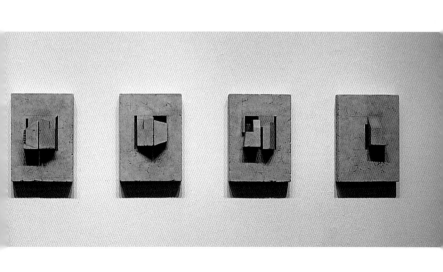

Brenda B. Townsend

ABSTRACT KIMONO 12
28 x 16 inches (71.1 x 40.6 cm)

Cut; handmade glazes; raku fired

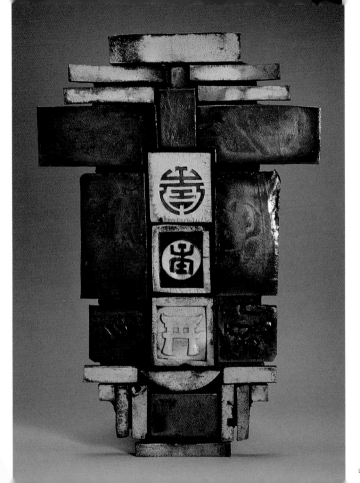

Kala Stein

PHRENOLOGICAL MAP OF THE HEAD

$5\frac{1}{2}$ x $5\frac{1}{2}$ x 1 inches (14 x 14 x 2.5 cm)

Slip-cast porcelain; cone 10 reduction;
laser-printed decal, cone 05 oxidation

PHOTO BY ARTIST

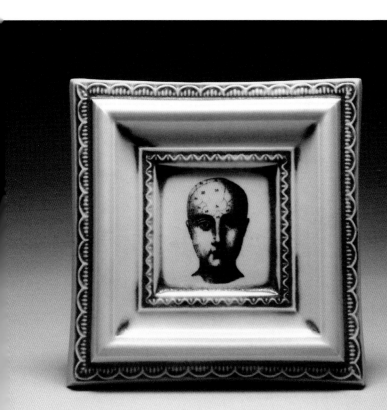

Beverlee Lehr

WINTER PLAY
12 x 12 x 2 inches (30.5 x 30.5 x 5.1 cm)

Hand-built stoneware; original glazes;
reduction fired, cone 10

PHOTO BY SOCOLOW PHOTOGRAPHY

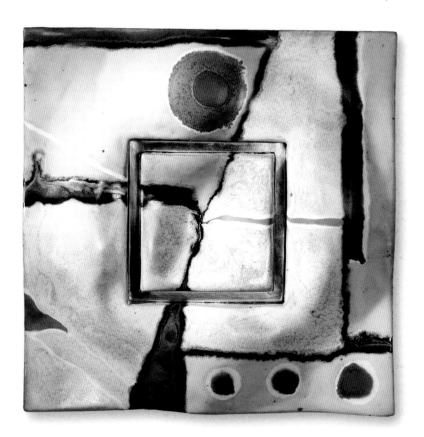

Ivy Glasgow

OPAL BLUE BUTTONS, MODERN SERIES

Each: $4\frac{1}{2}$ x $4\frac{1}{2}$ x $\frac{1}{2}$ inches (11.4 x 11.4 x 1.3 cm)

Press-molded and altered stoneware; fired, cone 6

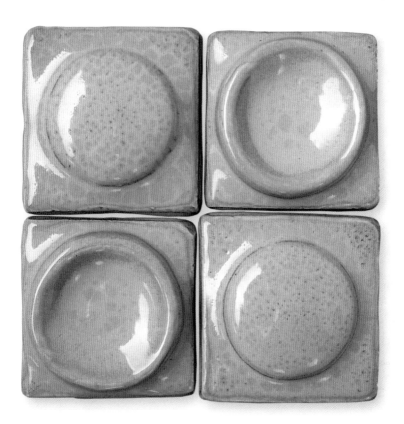

Vinod Kumar Daroz

GARBA-GRIHA (TEMPLE SERIES)

12 x 12 x 1¼ inches (30.5 x 30.5 x 3.2 cm)

Wheel-thrown stoneware; gas fired, cone 10;
glazed; gold luster fired, 1562°F (850°C)

PHOTO BY ARTIST

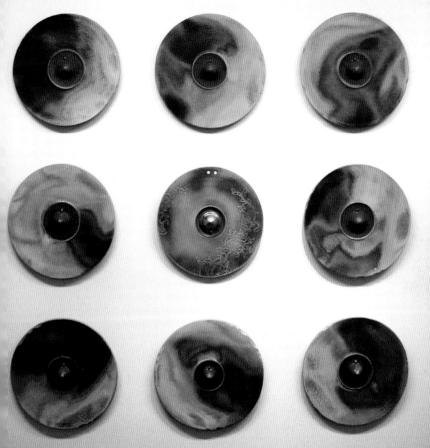

Marcia Reiver

COMPASS ROSE
2 x 15¾ inches (5.1 x 40 cm)

Slab-rolled and hand-cut tiles;
raku fired; natural bamboo tray

PHOTO BY JOHN CARLANO

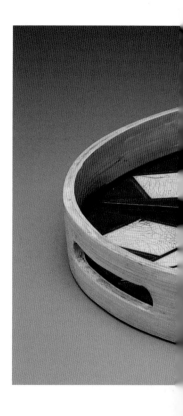

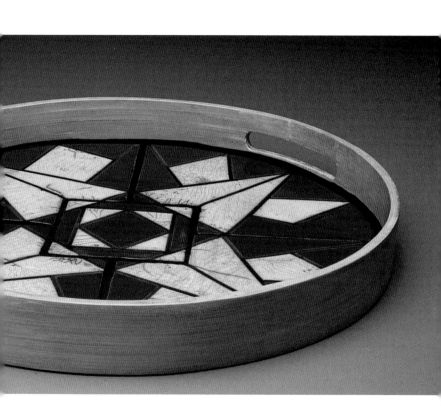

Katie Love

FIGURE 8
4 x 4 inches (10.2 x 10.2 cm)

Red stoneware; sgraffito

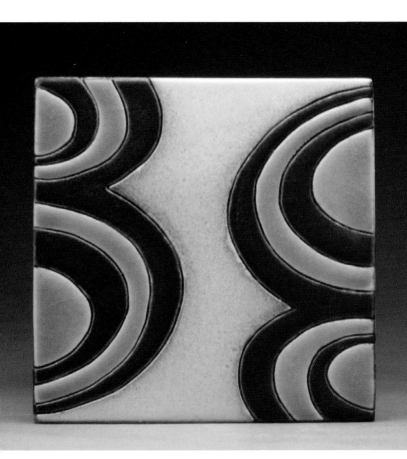

Rosalind Redfern

COPPER RED TILE PANEL
31 7/8 x 25 3/16 x 4 1/3 inches (81 x 64 x 11 cm)

Thrown stoneware; gas fired, cone 10-11; glazed

PHOTO BY WOLFGANG ALTMANN

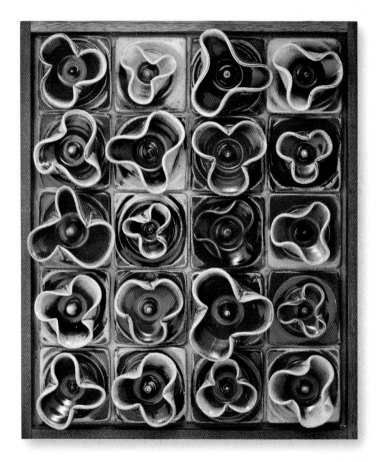

Carol Rose Dean

DANCING BEAR
20 x 14 x ¾ inches (50.8 x 35.6 x 1.9 cm)

Newcomb stoneware; mid-range cone 6; hand-carved

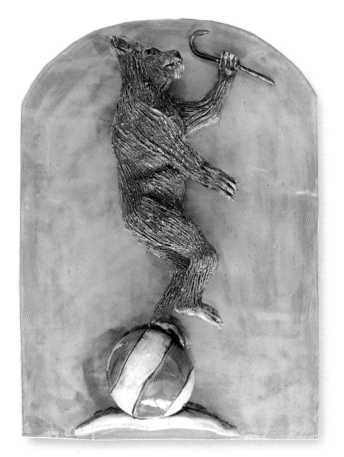

Rytas Jakimavičius

BOWL

57 x 47 3/16 x 1 3/8 inches (145 x 120 x 3.5 cm)

Hand-built earthenware; wood fired in reduction; recycled tiles

PHOTO BY VIDMANTAS ILLČIUKAS

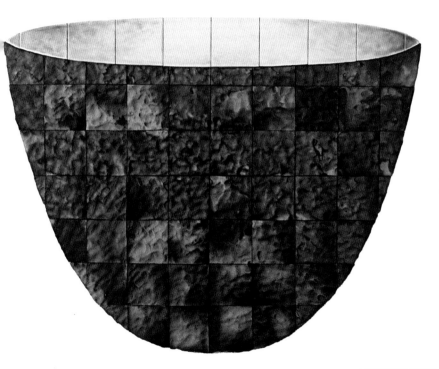

Sara Behling

FLUENT COMPOSITION

4 x 2¾ x ¹⁄₁₆ inches (10.2 x 7 x 0.2 cm)

Thrown and altered translucent porcelain; electric fired,
cone 06; celadon glaze, reduction fired cone 10; downfired;
mother-of-pearl luster glaze, cone 018; platinum luster, cone 022

PHOTO BY CHARLIE RAY

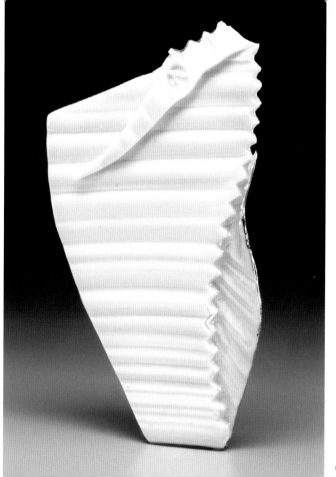

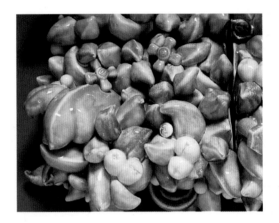

Susan Beiner

PERPETUAL RECOLLECTION
45 x 52 x 8 inches (114.3 x 132.1 x 20.3 cm)

Slip-cast and assembled porcelain; gas fired, cone 6

PHOTOS BY SUSAN EINSTEIN

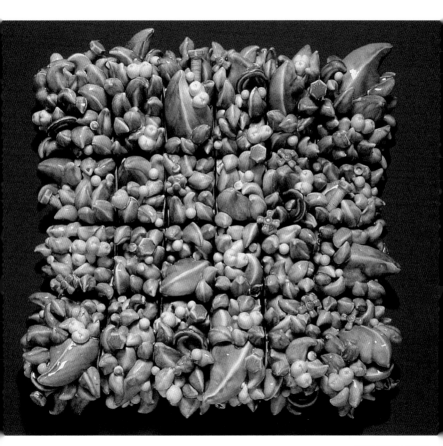

Jeff Reich

AGAVE

9 x 9 x ¼ inches (22.9 x 22.9 x 0.6 cm)

Hand-built stoneware; reduction fired,
 cone 10; crawling glaze and glaze sgraffito

PHOTO BY FARRADAY NEWSOME

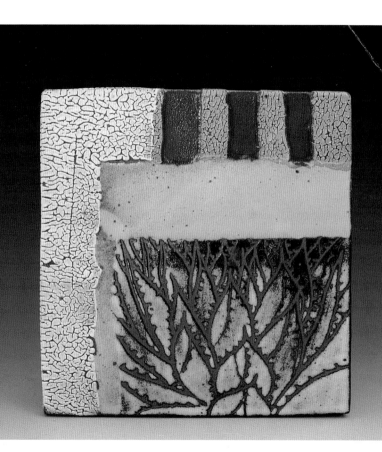

Elaine Xenelis Fuller

**I AM OF THE NATURE TO GROW OLD.
THERE IS NO WAY TO ESCAPE GROWING OLD.**

6 x 6 inches (15.2 x 15.2 cm)

Porcelain; underglaze pencil, glaze and
glass fired to cone 6 in oxidation

PHOTO BY ARTIST

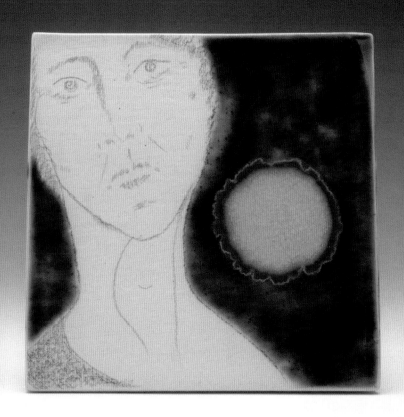

Lai Gong

BLUE ENERGY
4 x 4 x $\frac{1}{2}$ inches (10.2 x 10.2 x 1.3 cm)

Raku clay; copper blue glaze

PHOTO BY TOM CLARK

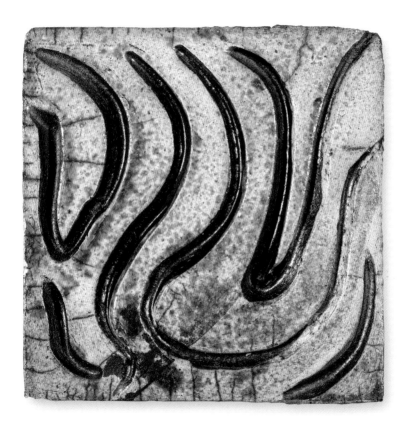

Susan Cohen

BRAZOS V

18⁹⁄₁₆ x 11¼ x 1¼ inches (47.1 x 28.6 x 3.2 cm)

Stoneware; glazed and pit-fired;
 accented with oil paint and silver dust

PHOTO BY MICHAEL LATIL

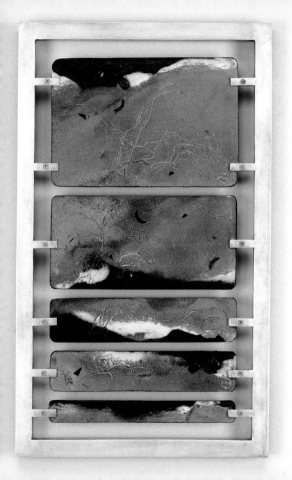

Brenda McMahon

PLANETARY MOONRISE: FIRE PAINTING
5 x 15 x ¼ inches (12.7 x 38.1 x 0.6 cm)

Slab-rolled stoneware; saggar fired, cone 04

PHOTO BY JASON LACHTARA

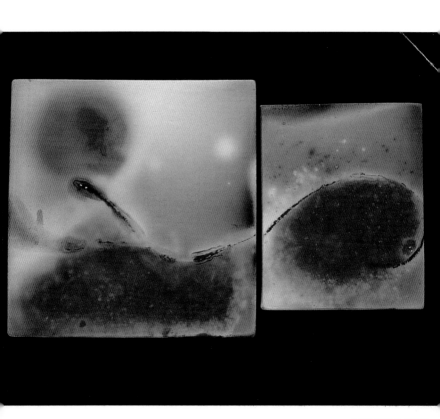

Ian Dowling

TILE PULSE

47 ³/₁₆ x 117 ⁷/₈ x 2 ³/₄ inches (120 x 300 x 7 cm)

Slip cast; glazed; gas fired,
cone 6, copper oxide

PHOTO BY ROBERT FRITH

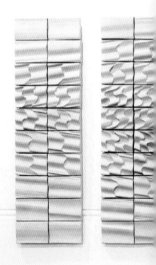

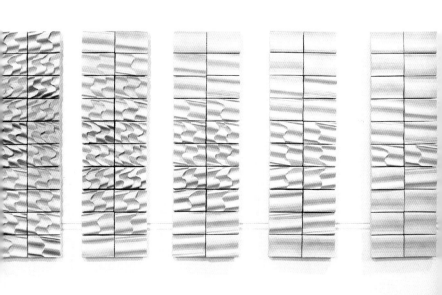

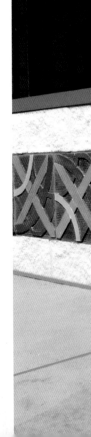

Gregory Aliberti

PARMATOWN TRANSIT CENTER, G.C.R.T.A.
Each: 16 x 16 inches (40.6 x 40.6 cm)

Ram-pressed; underglazed, cone 1

PHOTO BY ARTIST

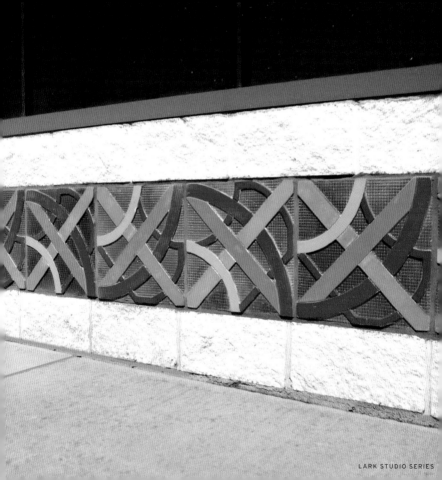

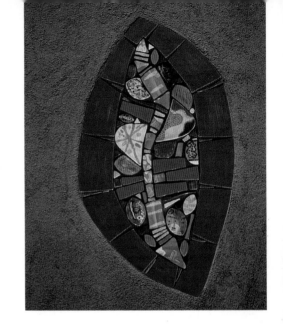

Ruth O'Day

LEAF FORMS

Each: 16 x 36 inches (40.6 x 91.4 cm)

Hand-cut sculpture clay; electric fired,
cone 6; embedded in colored stucco

PHOTOS BY ARTIST

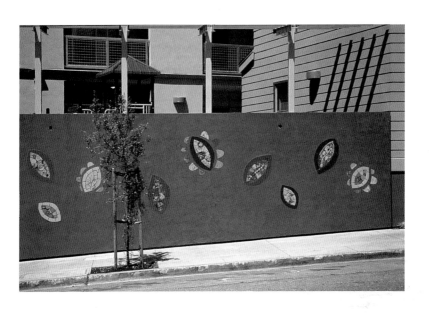

Colin Johnson

MOONFLOWER II (IN DARKNESS)

53$^{7}/_{8}$ x 81$^{1}/_{2}$ x 4 inches (137 x 207 x 10 cm)

Extruded buff clay, slab addition; sprayed
vitreous slip; electric fired, cone 4

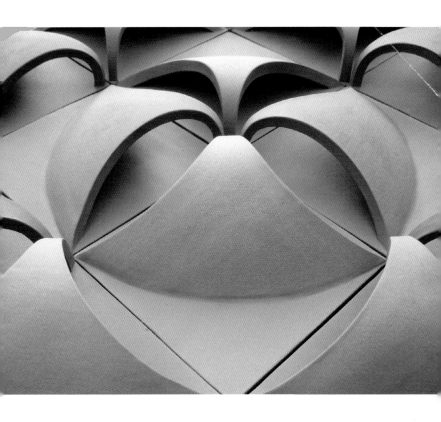

Melody Ellis

DOG-FACED BOY

5$\frac{1}{2}$ x 4$\frac{3}{4}$ x 1$\frac{1}{2}$ inches (14 x 12.1 x 3.8 cm)

Hand-carved earthenware; slips and
underglazes, cone 04; glazes, cone 05

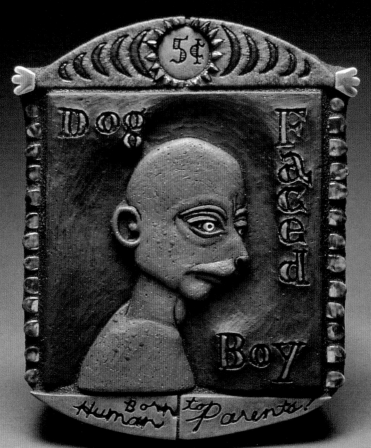

Dog Faced Boy

5¢

Born Human to Parents!

Rimas VisGirda

FREDERICK'S SF650-1

10$\frac{1}{2}$ x 11 x 1$\frac{1}{2}$ inches (26.7 x 27.9 x 3.8 cm)

Slab-rolled porcelain with granite; natural
edges, slip-trailed drawing; underglaze pencil;
electric fired, cone 10; lusters, cone 017

PHOTOS BY ARTIST

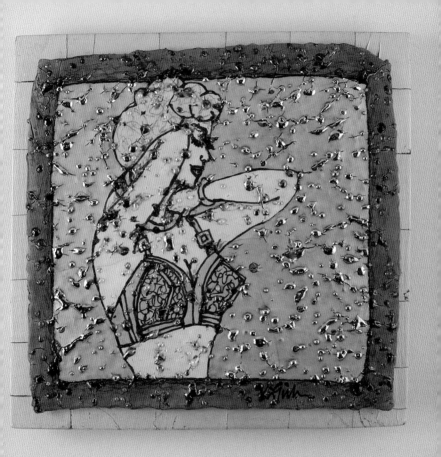

Judith Berk King

CAKE & FRIEND
10 x 9 x 1 inches (25.4 x 22.9 x 2.5 cm)

Earthenware; electric fired, cone 04; glazed, cone 06

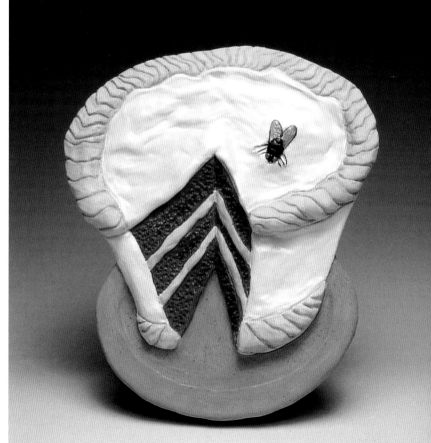

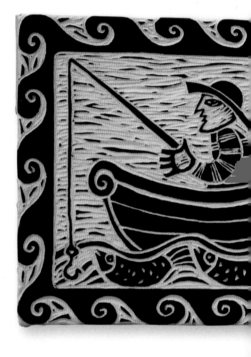

Terry Nicholas

FRESH CATCH
4 x 8 inches (10.2 x 20.3 cm)

Carved porcelain; black slip;
electric fired, cone 6

PHOTO BY ARTIST

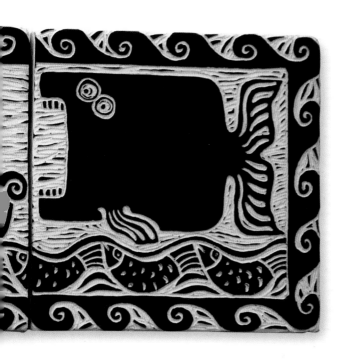

Claudia Riedener

PLOW (MASA SERIES)
18 1/2 x 15 x 1/2 inches (47 x 38.1 x 1.3 cm)

Hand-carved white stoneware;
electric fired, cone 6; Mason stain

PHOTOS BY JOHN CARLTON

Gabrielle Fougere

ONION

5¼ x 3 x ¼ inches (13.3 x 7.6 x 0.6 cm)

Slab-rolled stoneware with black slip;
gas fired in reduction, cone 10

PHOTO BY MONICA RIPLEY

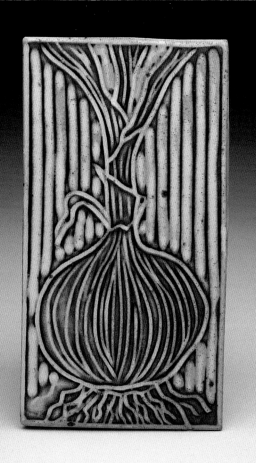

Rosemary Murray

SITTING BOY

5½ x 4 x ⅜ inches (14 x 10.2 x 1 cm)

Terra cotta; electric fired, cone 1

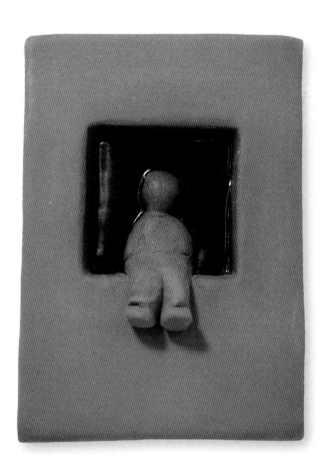

Melody Dalessandro Bonnema

REMEMBERING TOM THOMSON II
7 x 7 x ½ inches (17.8 x 17.8 x 1.3 cm)

Hand-rolled stoneware; gas fired in reduction, cone 9

PHOTO BY STEVE TRAFICONTE

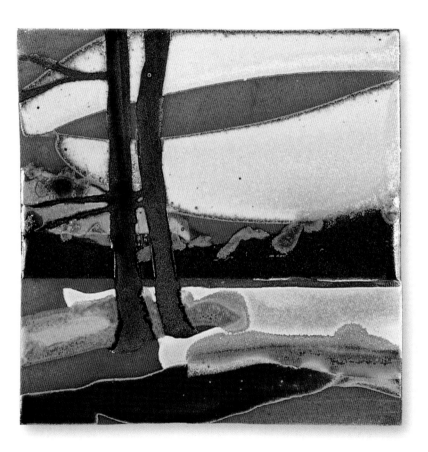

Amourentia Louisa Leibman

ICON

8$\frac{1}{2}$ x 8$\frac{1}{2}$ x $\frac{1}{4}$ inches (21.6 x 21.6 x 0.6 cm)

Earthenware; electric fired; stains on bisque;
transparent glaze over stains, cone 06

PHOTO BY ARTIST

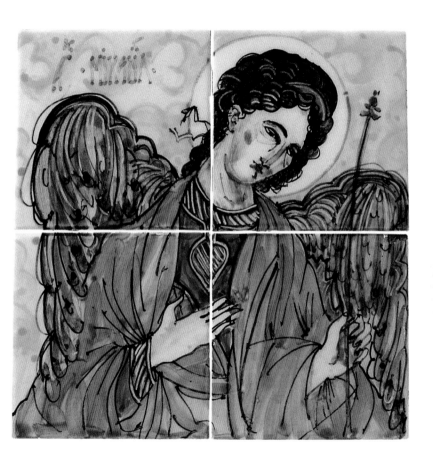

Sandi Langman

EMPIRE

5⅝ x 2¹³⁄₁₆ x ¼ inches (16.8 x 18.3 x 0.6 cm)

Press-molded; oxidation fired, cone 6

PHOTO BY LENNY GOTTER

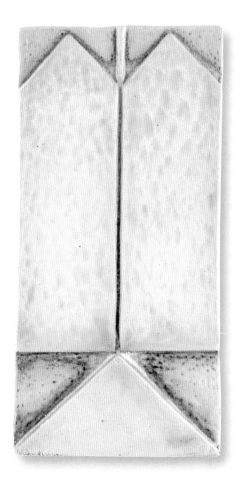

Ted Vogel

BLACK SKY
24 x 12 x 2 inches (61 x 30.5 x 5.1 cm)

Glazed ceramic, kiln cast and etched glass; cone 07

PHOTO BY ARTIST

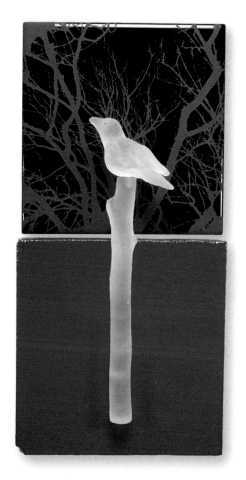

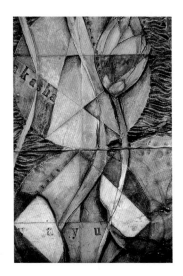

Mona M. Shiber

SACRED GEOMETRY: LOTUS CHAKRADARSHI I
48 x 18 x 2 inches (121.9 x 45.7 x 5.1 cm)

Hand-carved stoneware; reduction fired, cone 01
with slips, stain, oxide washes, and glazes

PHOTOS BY M. SHIBER/COMMERCIAL 35 (MAIN); JOSEPH GRUBER (DETAIL)

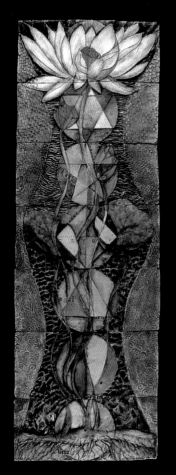

Janet Fergus

MONKEY FOUNTAIN PANEL

18 x 12 x 3/8 inches (45.7 x 30.5 x 1 cm)

Press-molded earthenware; electric fired, cone 05;
hand-painted with commercial low-fire glazes

PHOTO BY ELIZABETH ELLINGSON

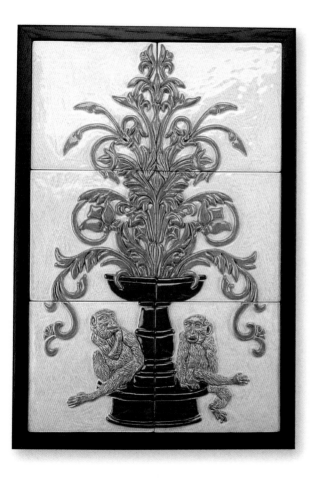

Bede Clarke

VESUVIUS
12 x 12 x 1 inches (30.5 x 30.5 x 2.5 cm)

Earthenware; engobes; electric fired, cone 03

PHOTO BY ARTIST

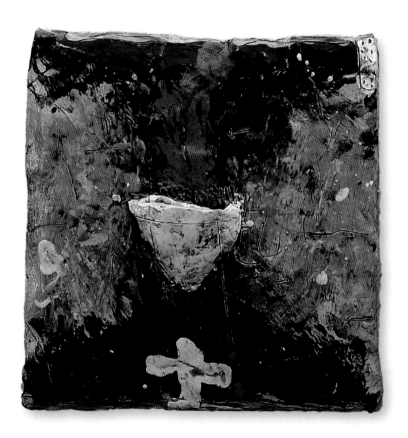

Danielle Booroff

ORNAMENTAL SPACE I

8¼ x 5⅛ x 2⅜ inches (21 x 13 x 6 cm)

Press-molded earthenware with extruded details;
electric fired, cone 04; glazed, cone 04

PHOTO BY ARTIST

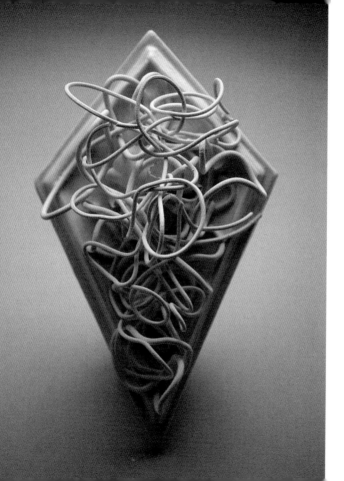

Betsy Toth
Pam Fletcher

OCTET

8 x 16 inches (20.3 x 40.6 cm)

Slab-rolled and hand-cut stoneware; bisque fired,
cone 011; stained and glazed, electric fired, cone 6

PHOTO BY GREGORY R. STALEY

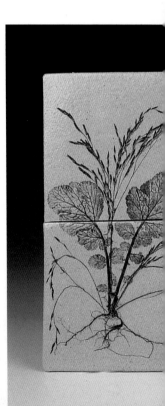

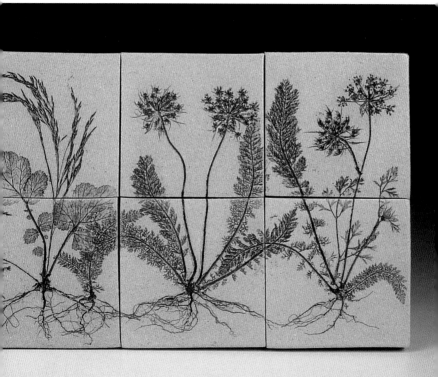

Tony Moore

BOTANICALS AND CROSS
11 x 11 x 1/2 inches (27.9 x 27.9 x 1.3 cm)

Wood-fired stoneware; impressed
botanicals, slip; multi-fired, cone 10

PHOTO BY HOWARD GOODMAN

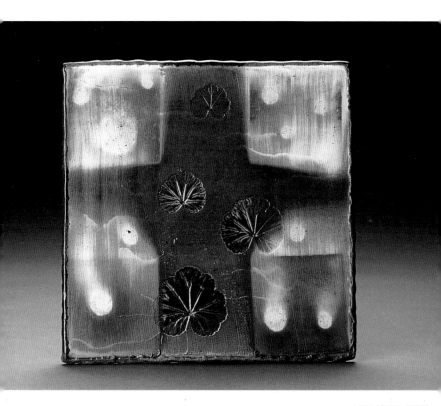

Jamie Lea Johnson

RESTING FIGURE
48 x 96 x ½ inches (121.9 x 243.8 x 1.3 cm)

Glazed; electric fired,
cones 06-04; grog, sand

PHOTO BY ARTIST

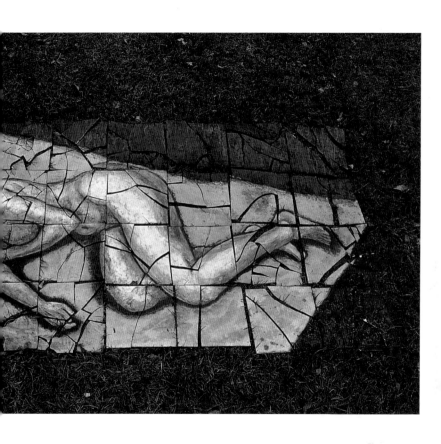

Anat Shiftan

FLOWER WITH BLUE DOTS
16 x 22 x ½ inches (40.6 x 55.9 x 1.3 cm)

Stoneware slab; electric fired, cone 2; glazed

PHOTO BY ARTIST

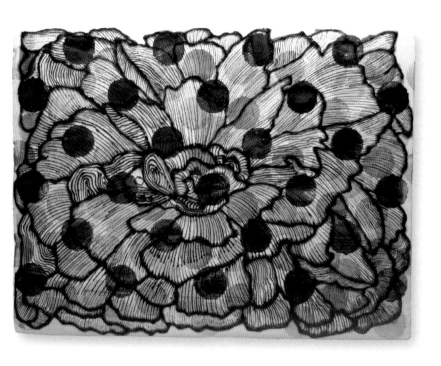

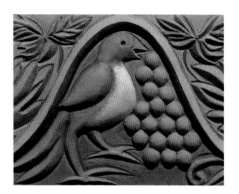

Carrie Anne Parks

BIRDS AND BERRIES TILES

15⅛ x 21¼ x 2 inches (38.4 x 54 x 5.1 cm)

Press-molded earthenware; electric fired,
cone 06; underglazed, cone 05

PHOTOS BY ARTIST

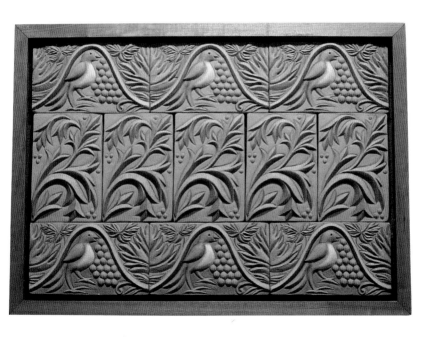

Fay Jones Day

TREE-LINED ROAD
6 x 6 x ½ inches (15.2 x 15.2 x 1.3 cm)

Terra cotta earthenware;
stain; electric fired, cone 05

PHOTO BY ARTIST

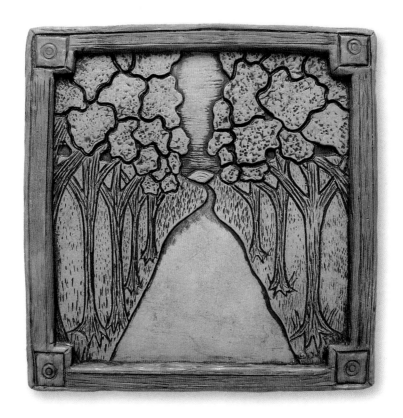

ARTIST INDEX

HUBER, KERI
St. Paul, Minnesota, 20

HUDIN, CATHRYN R.
Oroville, California, 24

HUDIN, LEE
Oroville, California, 24

HUIE, ELLEN
Chepachet, Rhode Island, 86

JAFFE, AMANDA
Las Cruces, New Mexico, 58

JAKIMAVIČIUS, RYTAS
Vilnius, Lithuania, 136

JENG-DAW, HWANG
Tainan, Taiwan, 12

JOHNSON, COLIN
Hastings, E. Sussex,
United Kingdom, 158

JOHNSON, JAMIE LEA
Bertram, Texas, 194

KING, JUDITH BERK
Miami Shores, Florida, 164

KLIEWER, LINDA
Battle Ground, Washington, 40

KOLENTSIS, DOT
Sydney, New South Wales,
Australia, 60

LANGMAN, SANDI
Portland, Oregon, 178

LAUČKAITÉ-JAKIMAVIČIENÉ,
DALIA
Vilnius, Lithuania, 54

LEHR, BEVERLEE
Palmyra, Pennsylvania, 122

LEIBMAN, AMOURENTIA LOUISA
Vancouver, British Columbia,
Canada, 176

LEVIN, SIMON
Gresham, Wisconsin, 8

LITVINOFF, LAURA
Milford, Connecticut, 34

LOVE, KATIE
Webster, New York, 130

MADAN, RUCHIKA
Somerville, Massachusetts, 80

MARR-FULLER, CHLOË
Somerville, Massachusetts, 92

MATRAY, MARTA
Minneapolis, Minnesota, 74

MCCAUL, LAURA
Danbury, Wisconsin, 46

MCMAHON, BRENDA
Port Washington, Ohio, 150

MENDES, JENNY
Chesterland, Ohio, 48

MEYER, HENNIE
Durbanville, Western Cape,
South Africa, 84

MOORE, TONY
Cold Spring, New York, 192

MURRAY, ROSEMARY
Victoria, British Columbia,
Canada, 172

NEWTON, SHAWN
Wallingford, Connecticut, 100

NICHOLAS, TERRY
Ponte Vedra, Florida, 166

NICKLOW, JONATHAN
Evergreen, Colorado, 10

NICKLOW, VALERIE
Evergreen, Colorado, 10

O'DAY, RUTH
Battle Mountain, Nevada, 156

OZEREKO, FRANK
Pelham, Massachusetts, 110

PARKS, CARRIE ANNE
Alma, Michigan, 198

REDFERN, ROSALIND
Next-the-Sea, Holt, Norfolk,
England, 132

REICH, JEFF
Mesa, Arizona, 142

REIVER, MARCIA
Rosemont, Pennsylvania, 128

REUTTER, LAURA A.
Port Town, Washington, 62

RIEDENER, CLAUDIA
Tacoma, Washington, 168

ROBB, JAN
Troy, Michigan, 108

SCHMIERER, TIFFANY
San Francisco, California, 14

SHIBER, MONA M.
Northampton, Massachusetts, 182

SHIFTAN, ANAT
New Paltz, New York, 196

SKEER, JANEY
Denver, Colorado, 78

SPALDING, DOUG
Royal Oak, Michigan, 30

STEIN, KALA
Alfred, New York, 120

SUTTER, LORRAINE
Saskatoon, Saskatchewan, Canada, 72

TOTH, BETSY
Warrenton, Virginia, 190

TOWNSEND, BRENDA B.
Alexandria, Virginia, 118

TRUMP, NOVIE
Falls Church, Virginia, 18

VISGIRDA, RIMAS
Champaign, Illinois, 162

VOGEL, TED
Portland, Oregon, 180

WANDLESS, PAUL ANDREW
Chicago, Illinois, 52

WARKENTIN, GARY
Estacada, Oregon, 42

WILBUR, WYNNE
Kirksville, Missouri, 28

WILSON, LANA
Del Mar, California, 50

WINK, SUSAN
Roswell, New Mexico, 114

WOLTERS, LISA
Yellow Springs, Ohio, 76

WOOD, NICHOLAS
Arlington, Texas, 116

Enjoy more of the books in the
LARK STUDIO SERIES

Art Tiles

Handmade Books

Chairs

Pendants